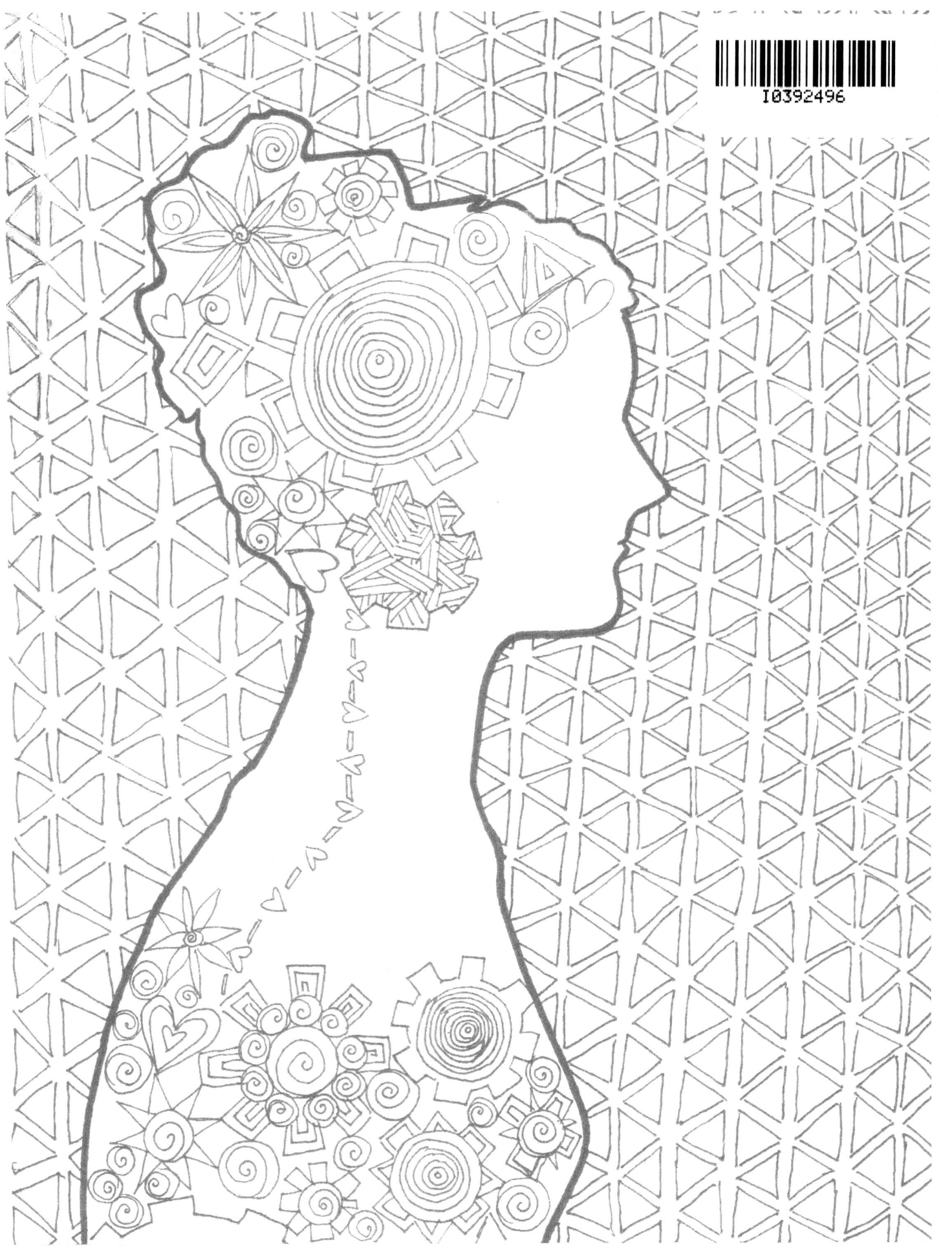

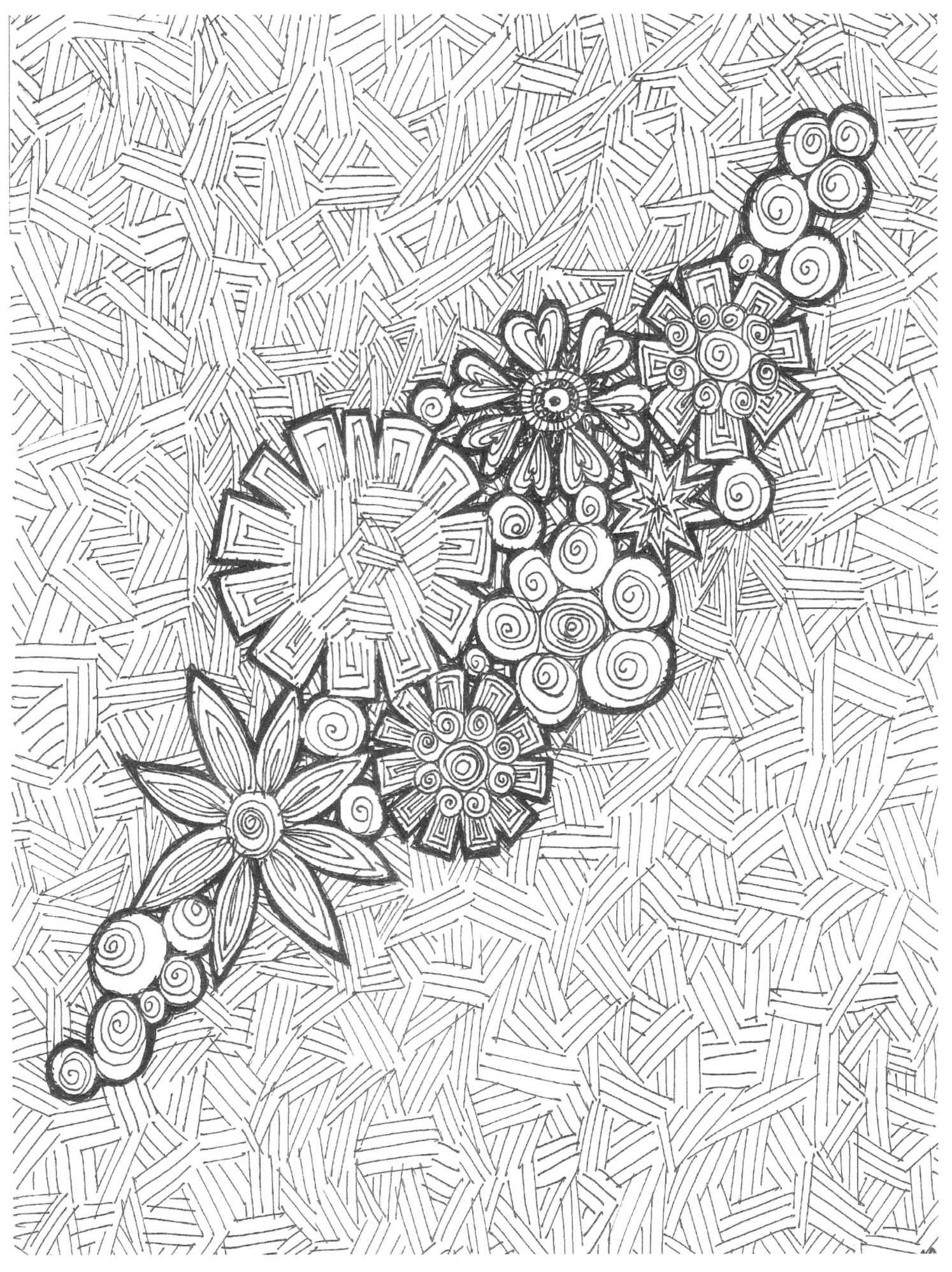

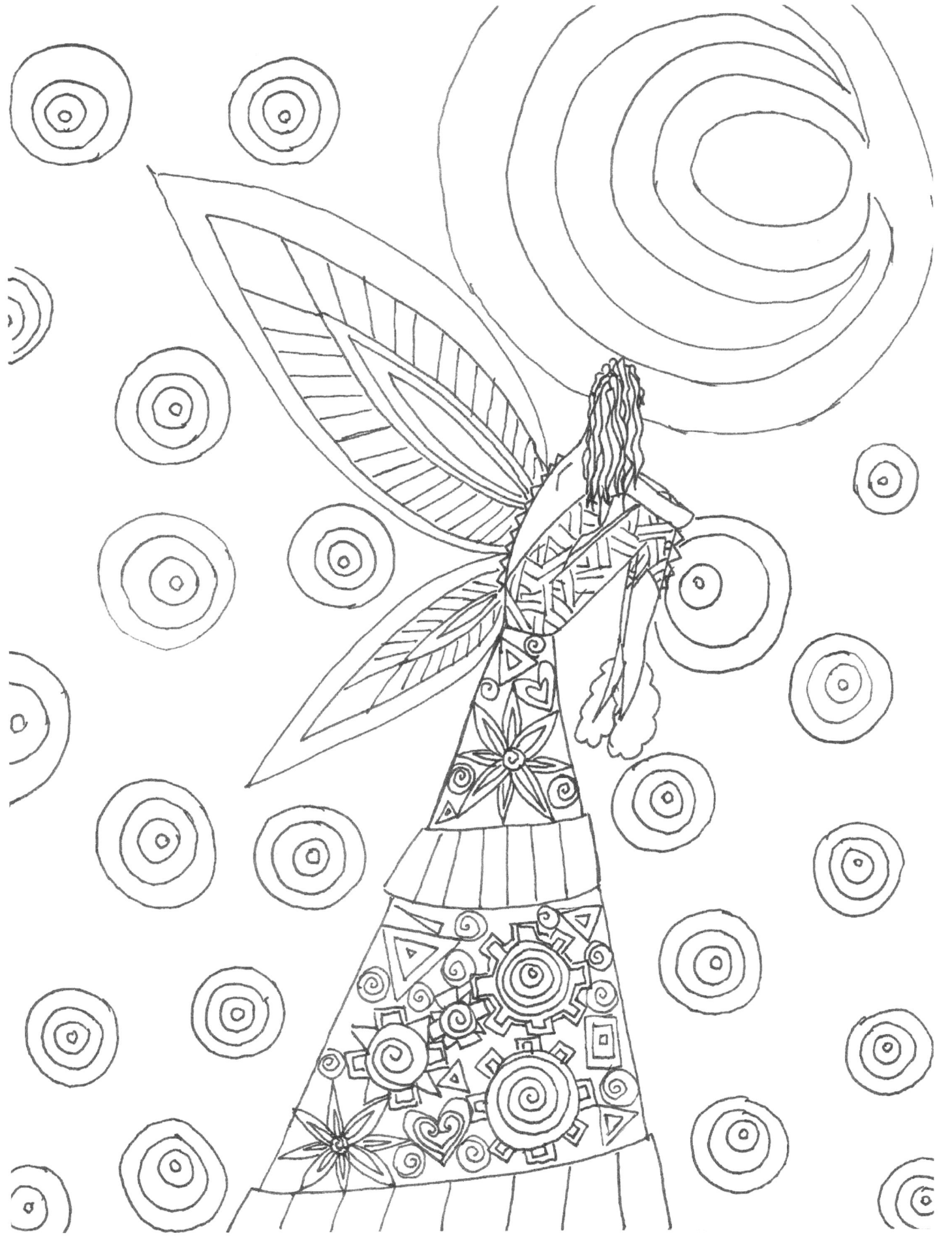

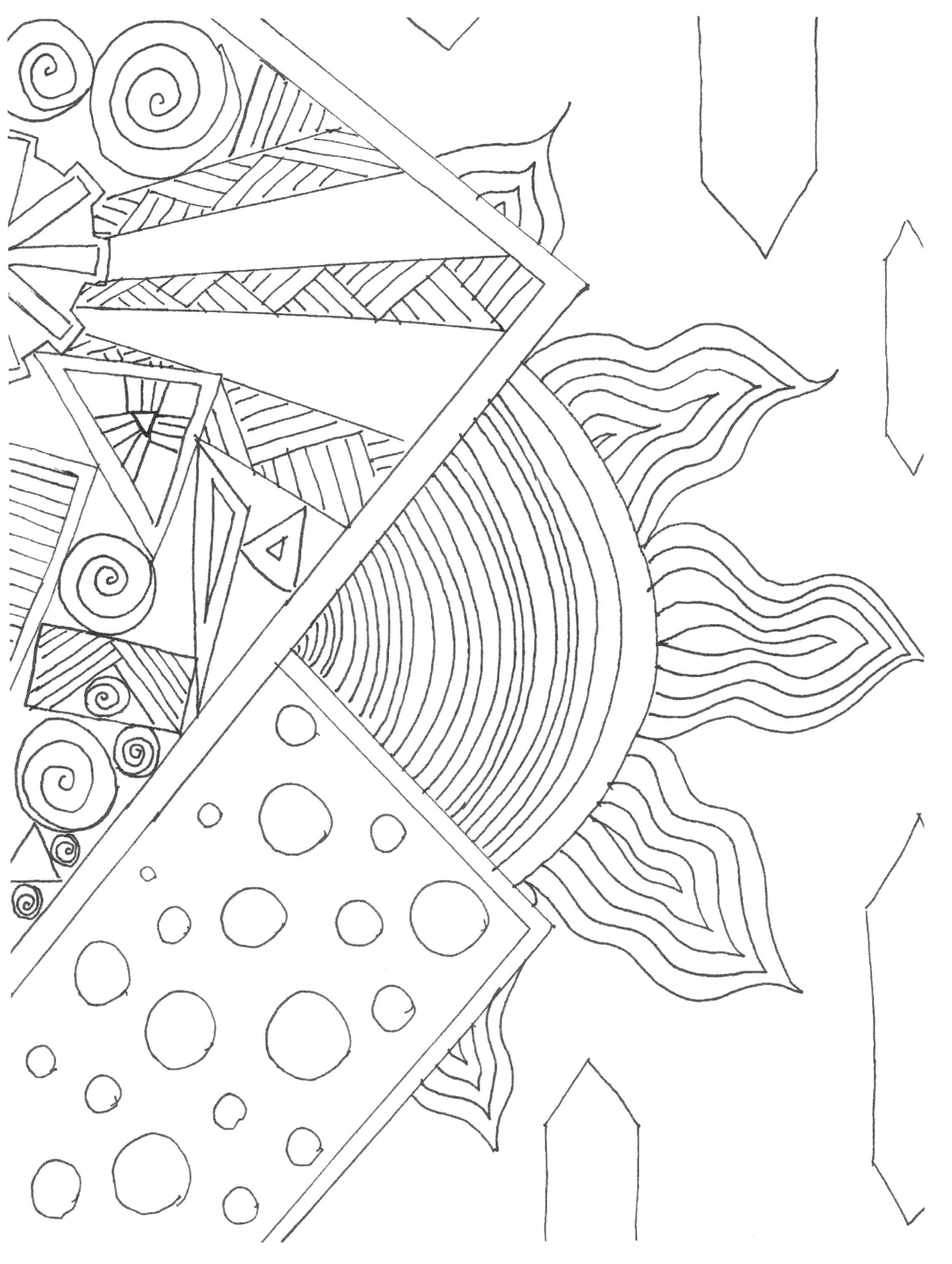

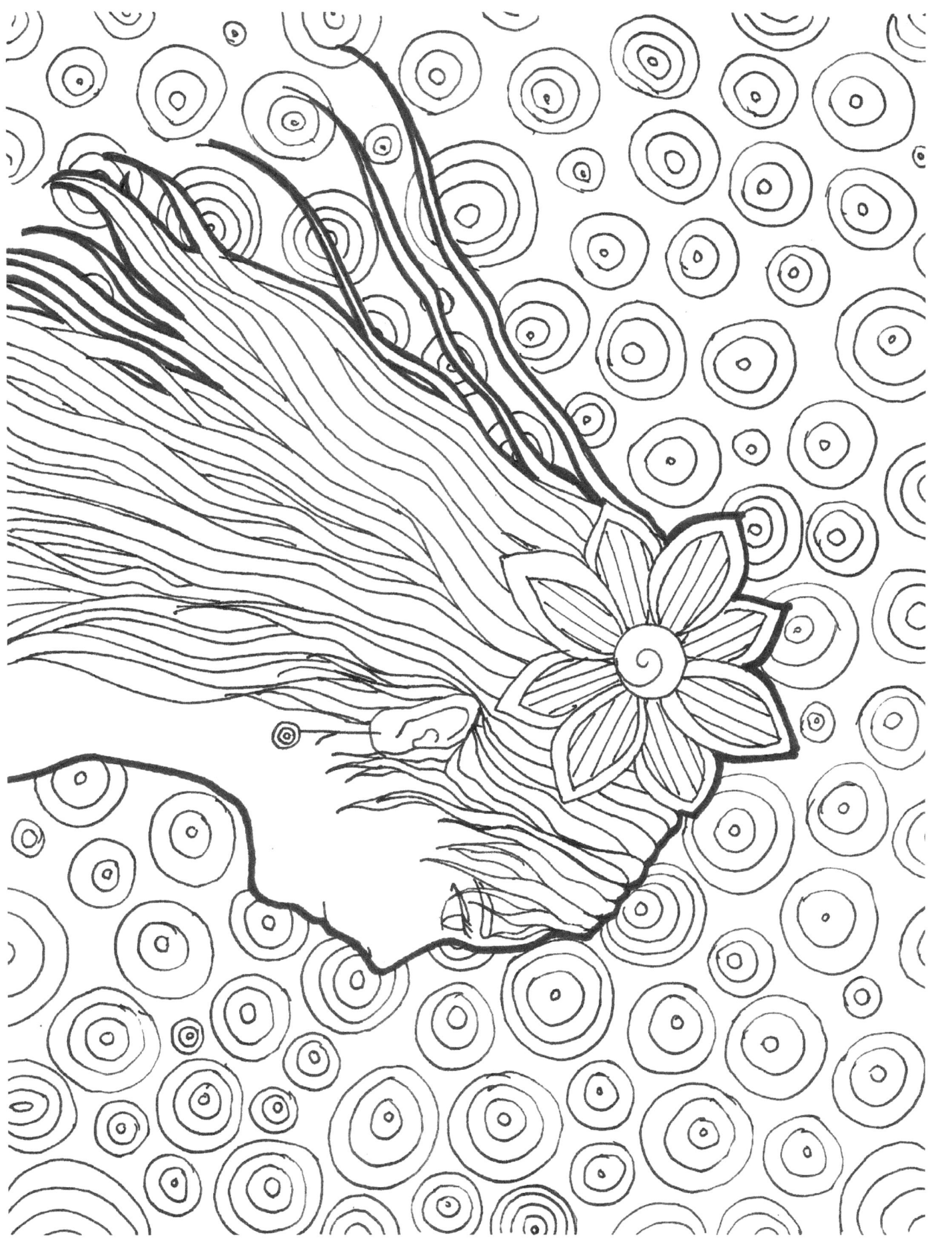

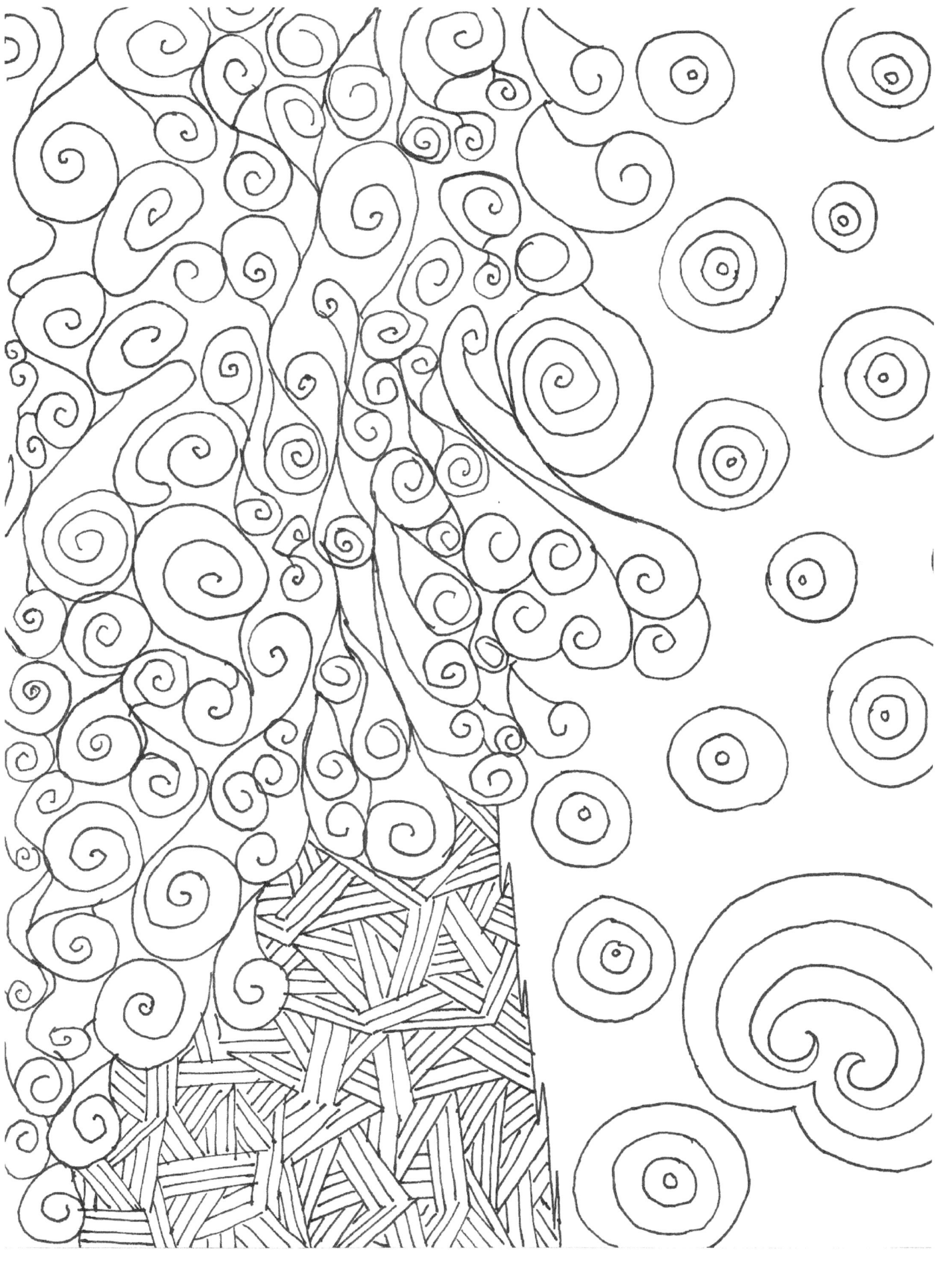

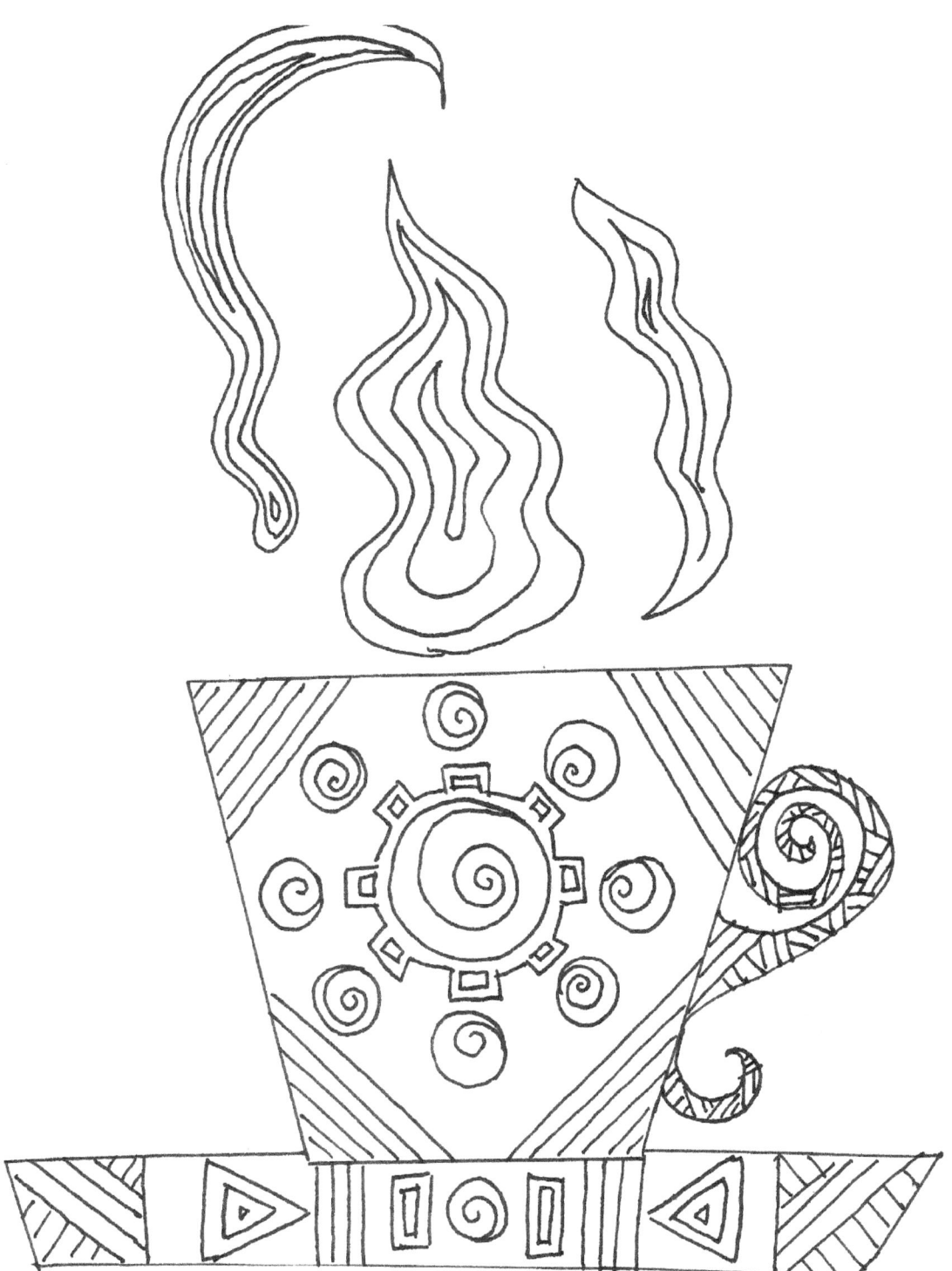

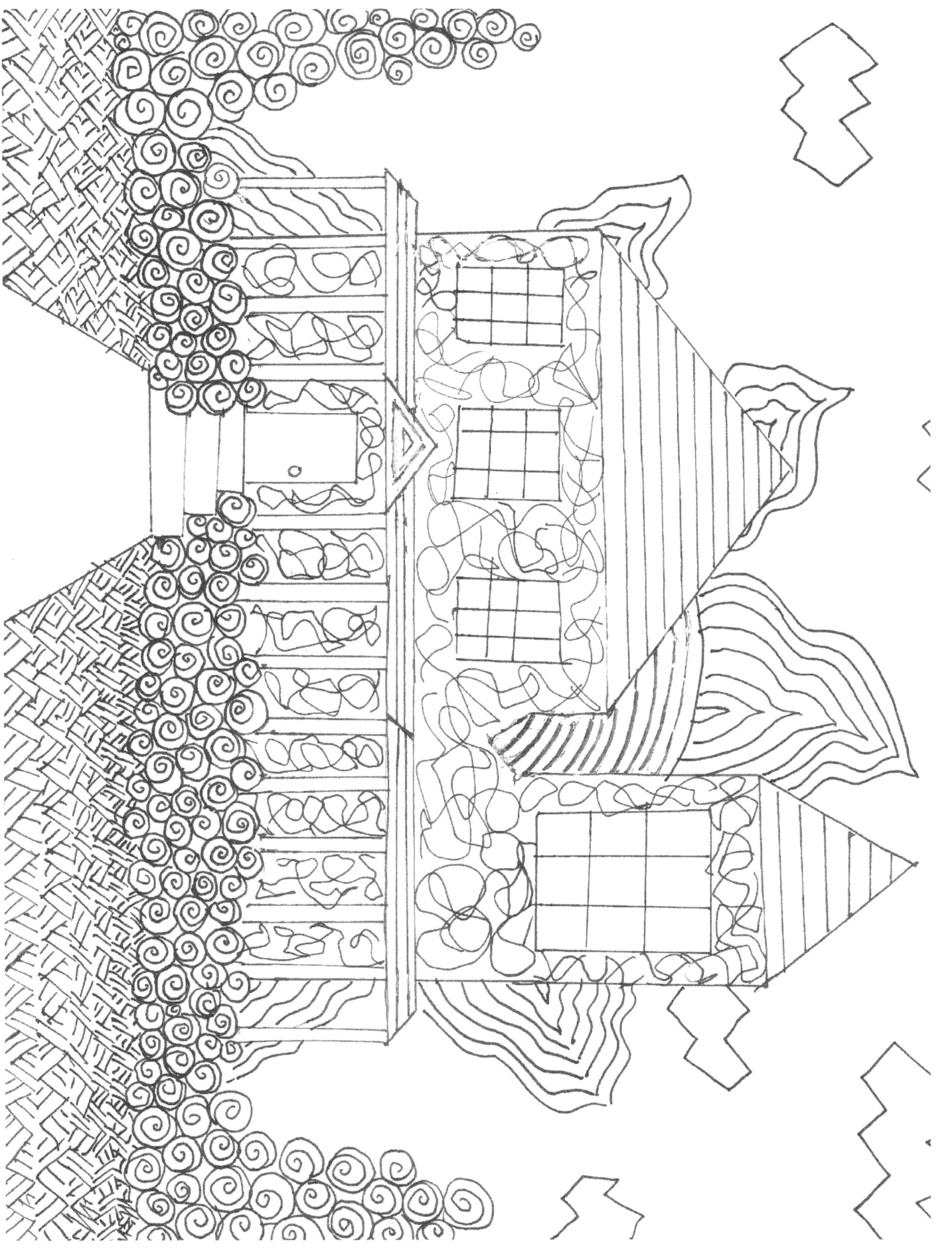

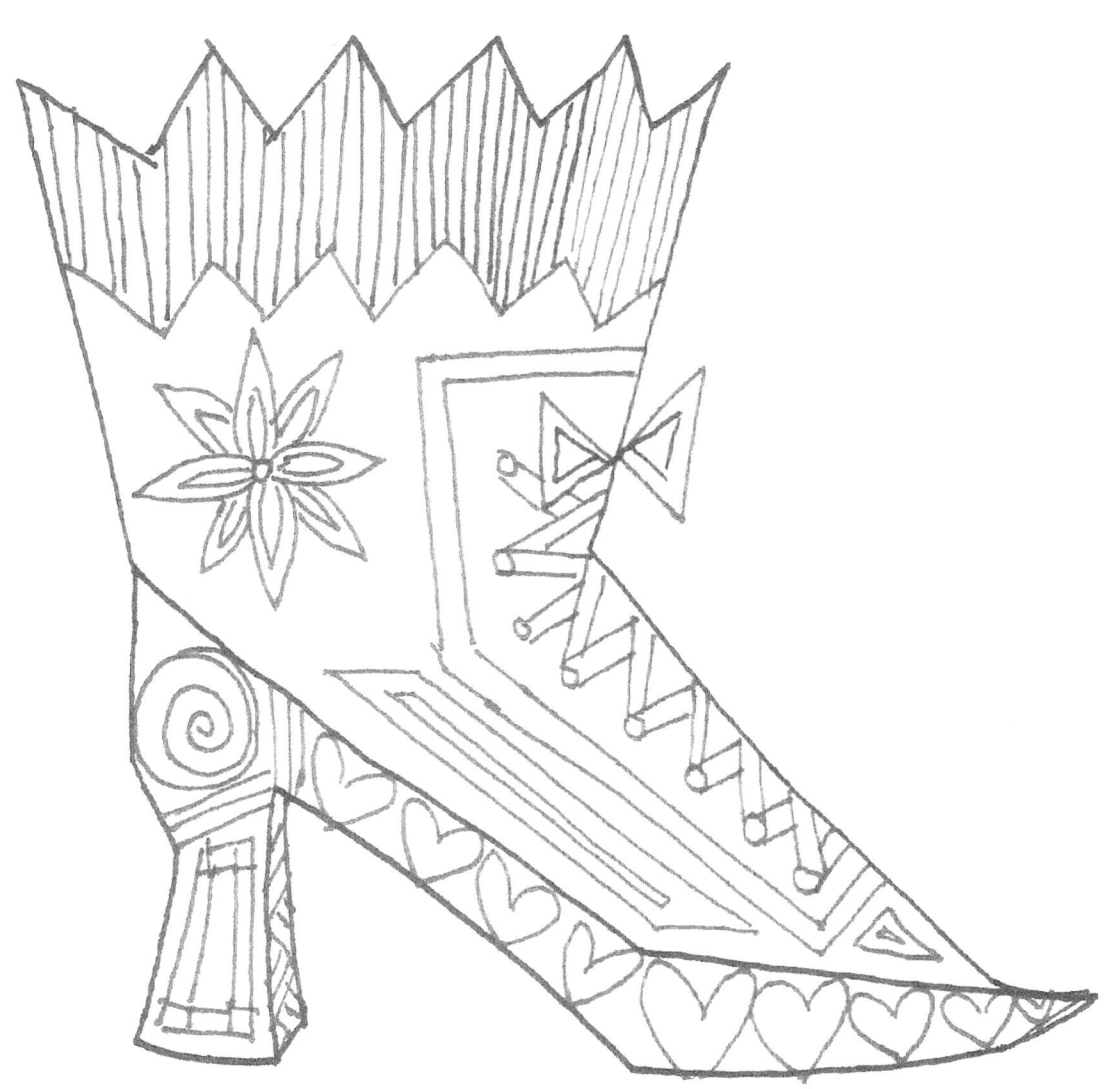

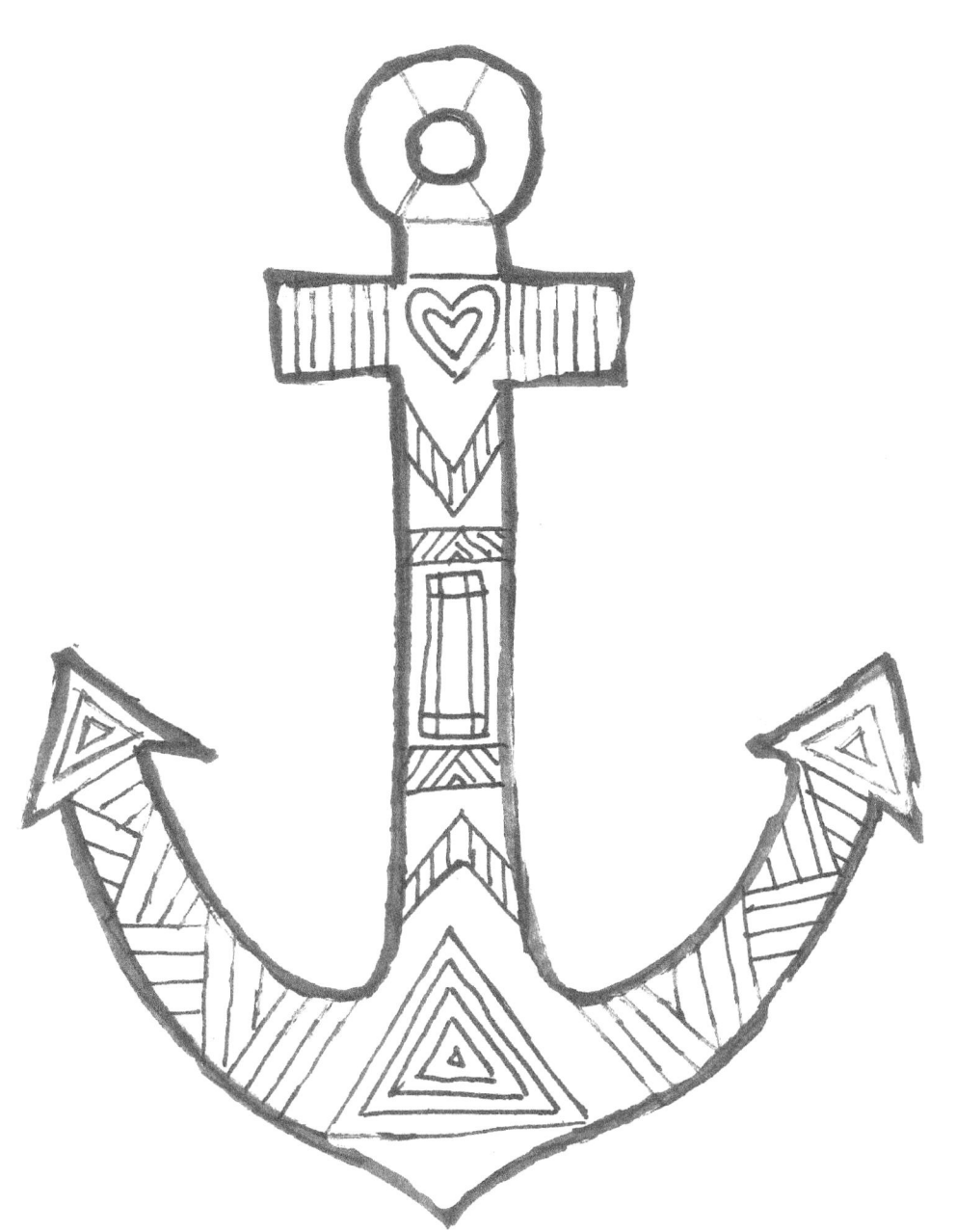

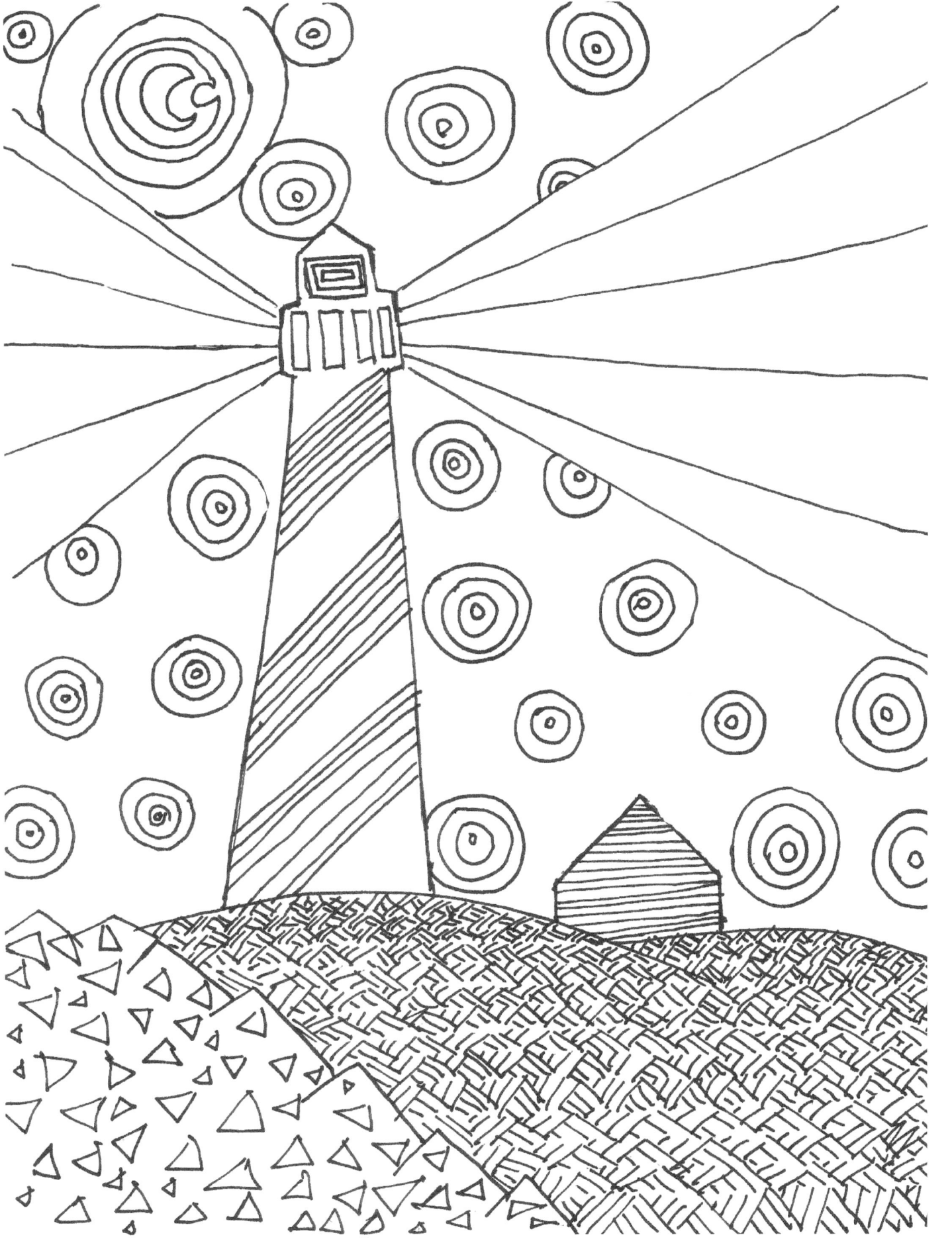

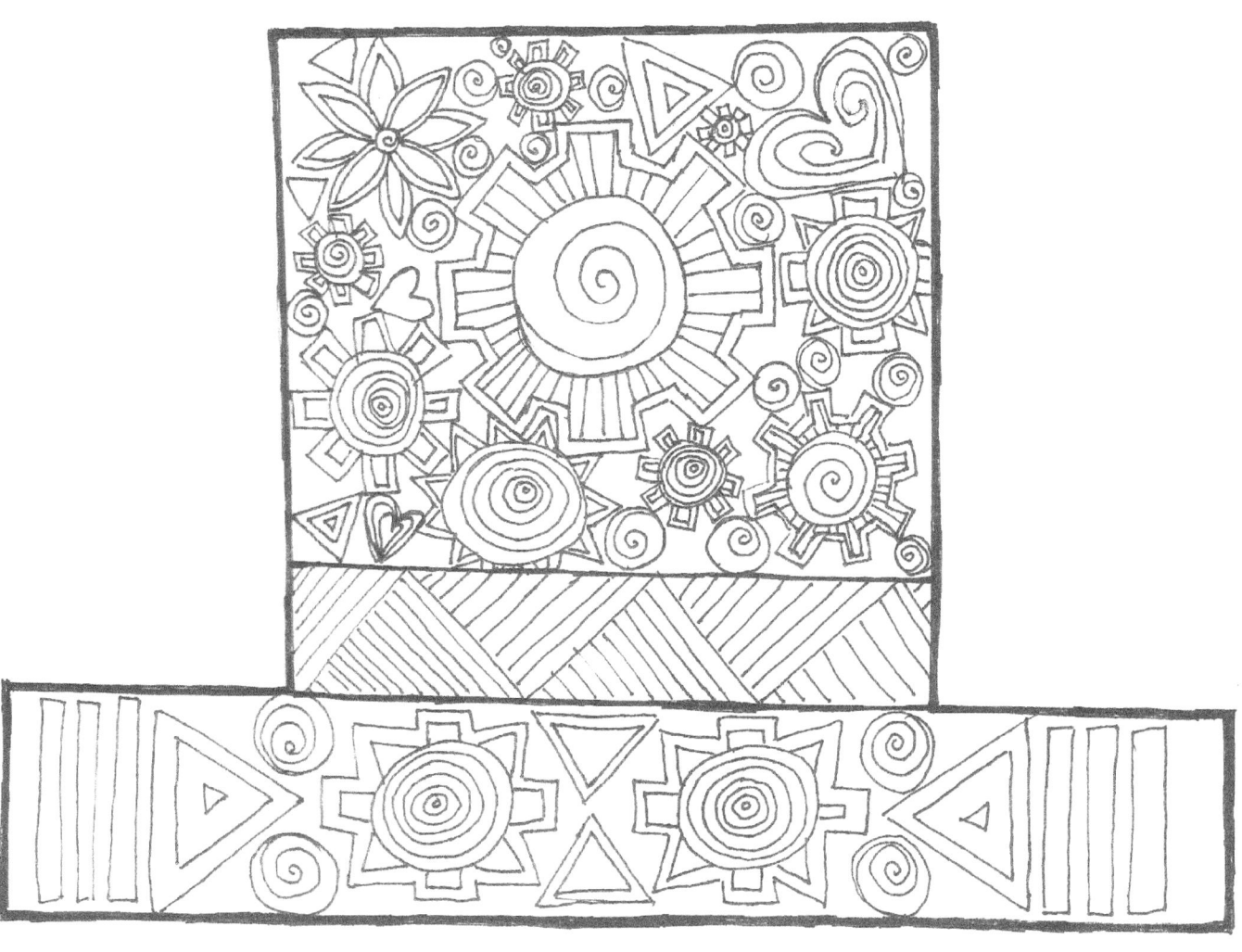

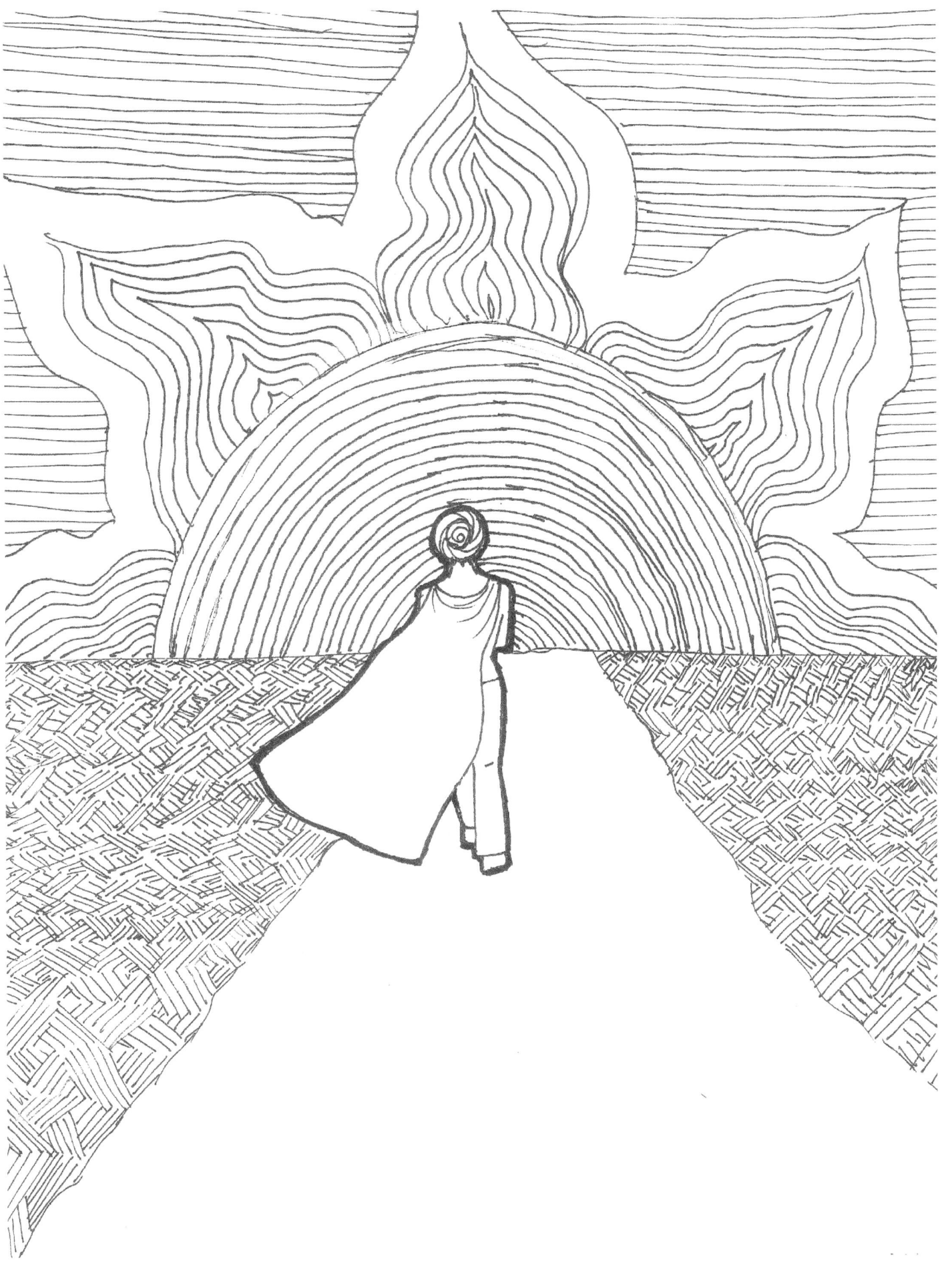

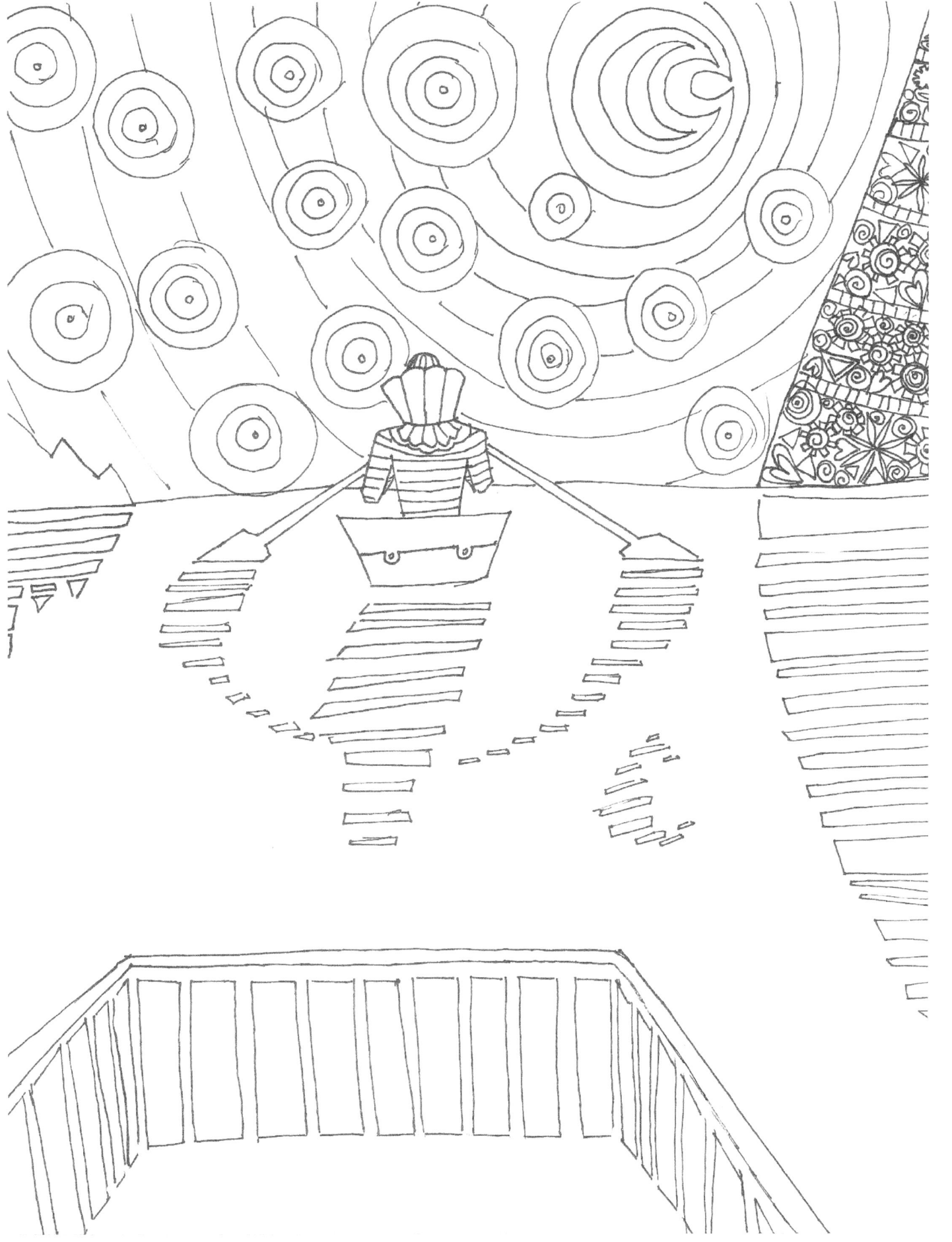

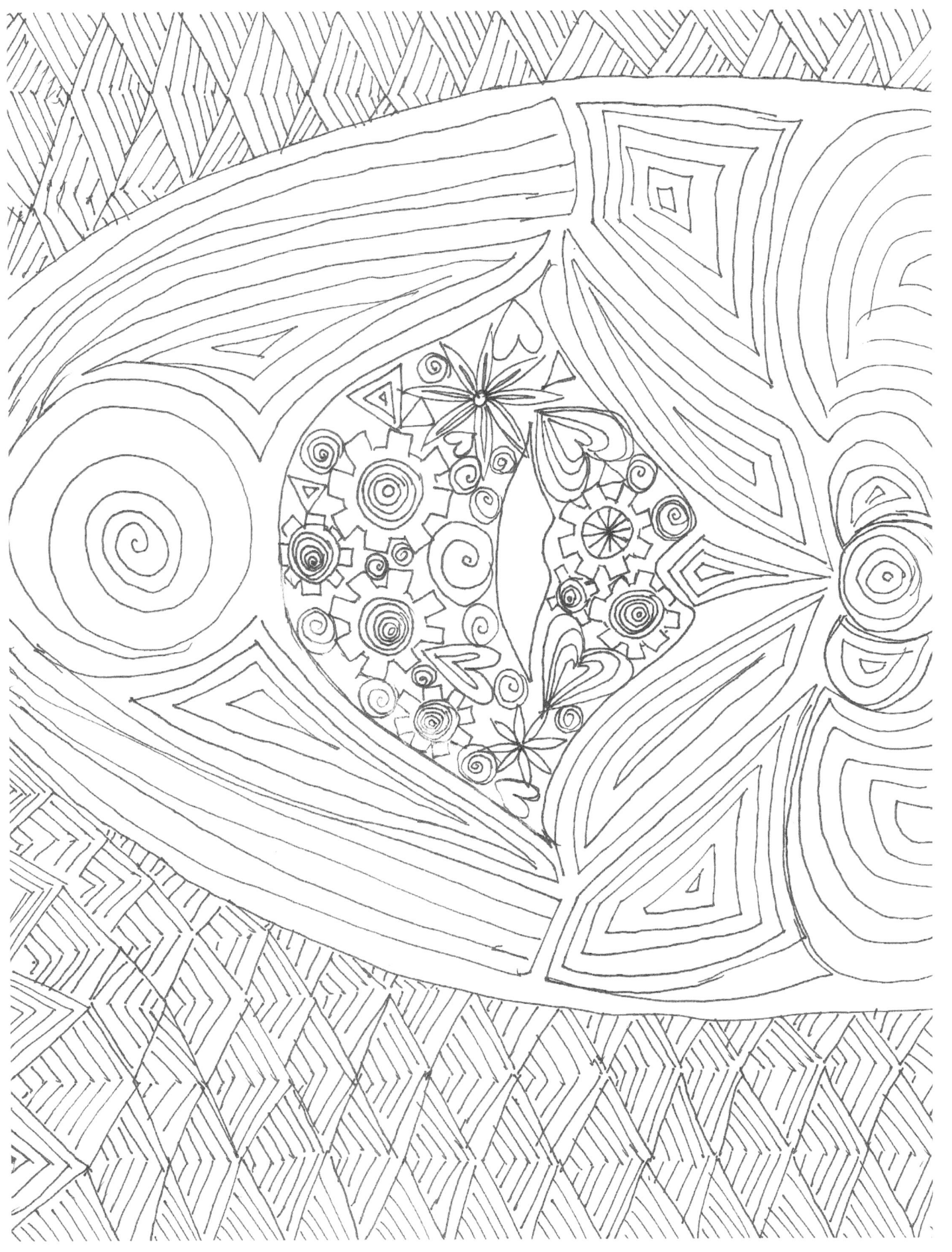

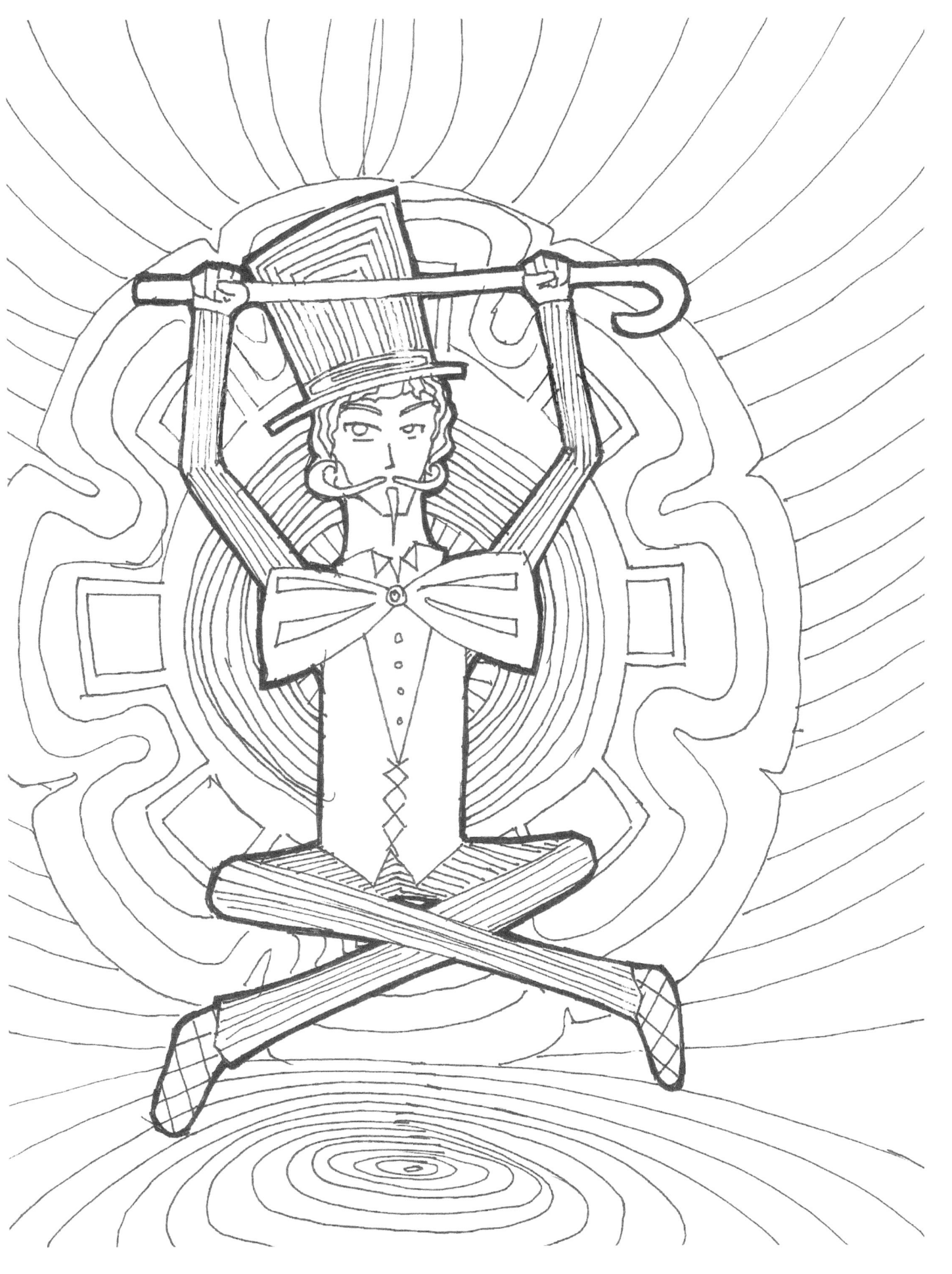

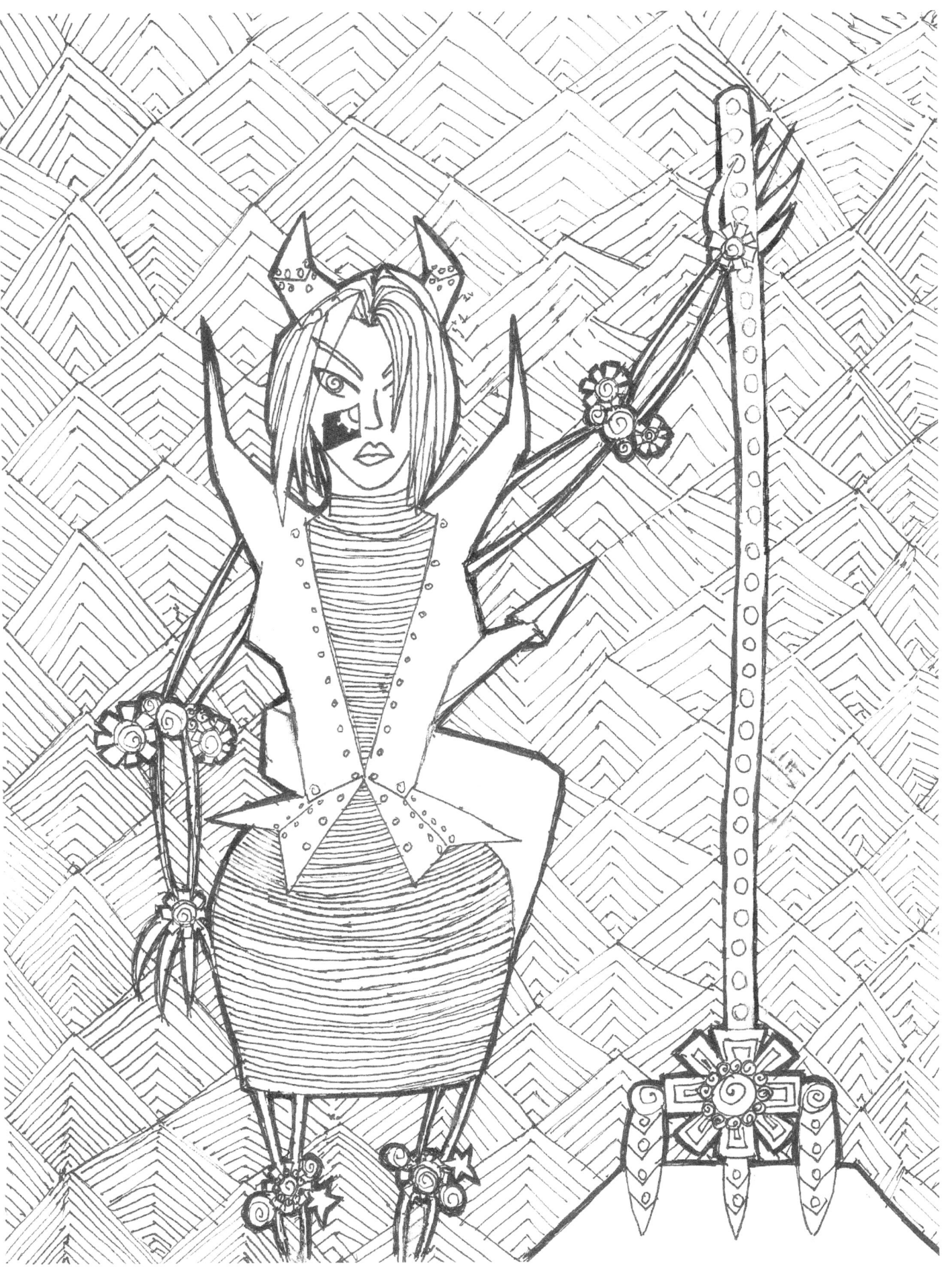

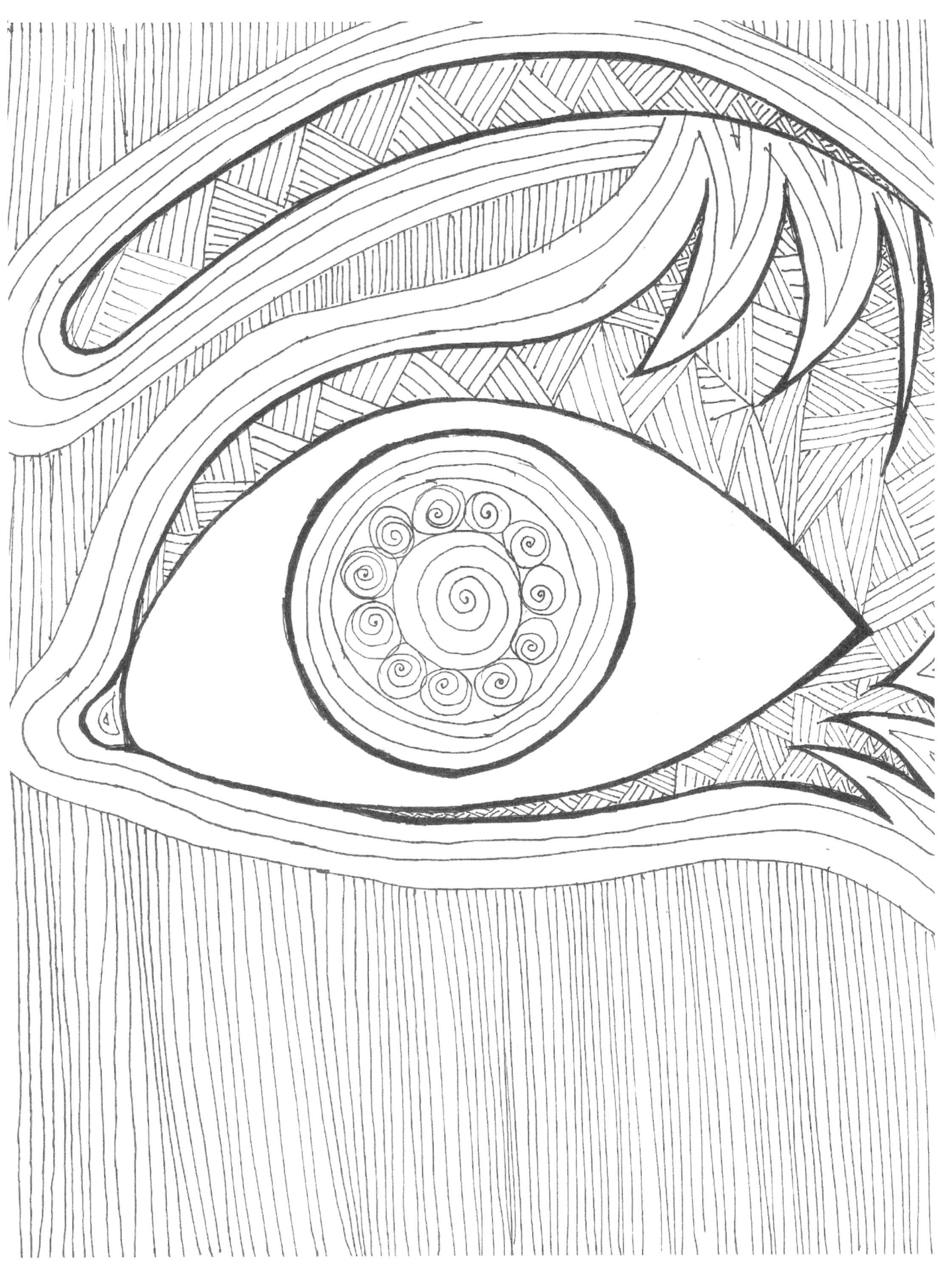

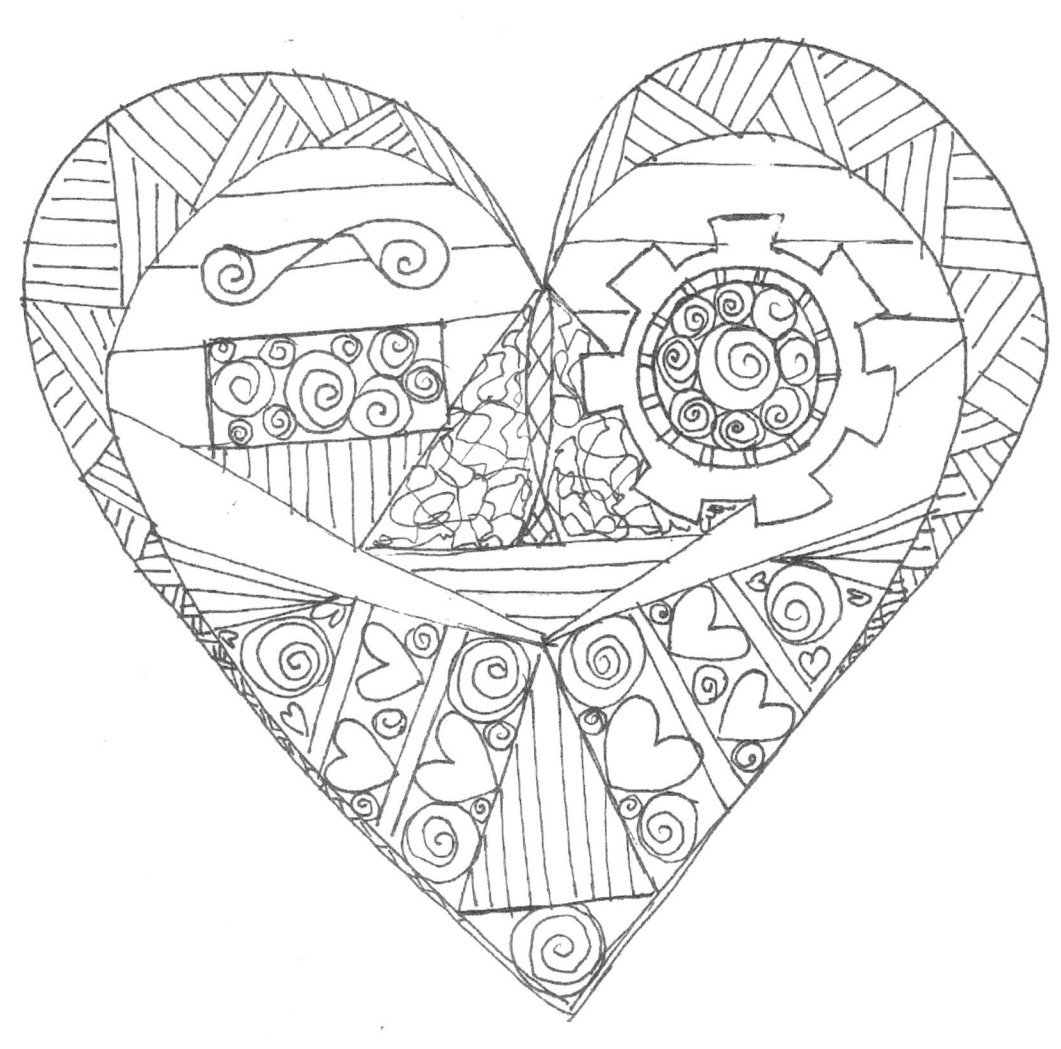

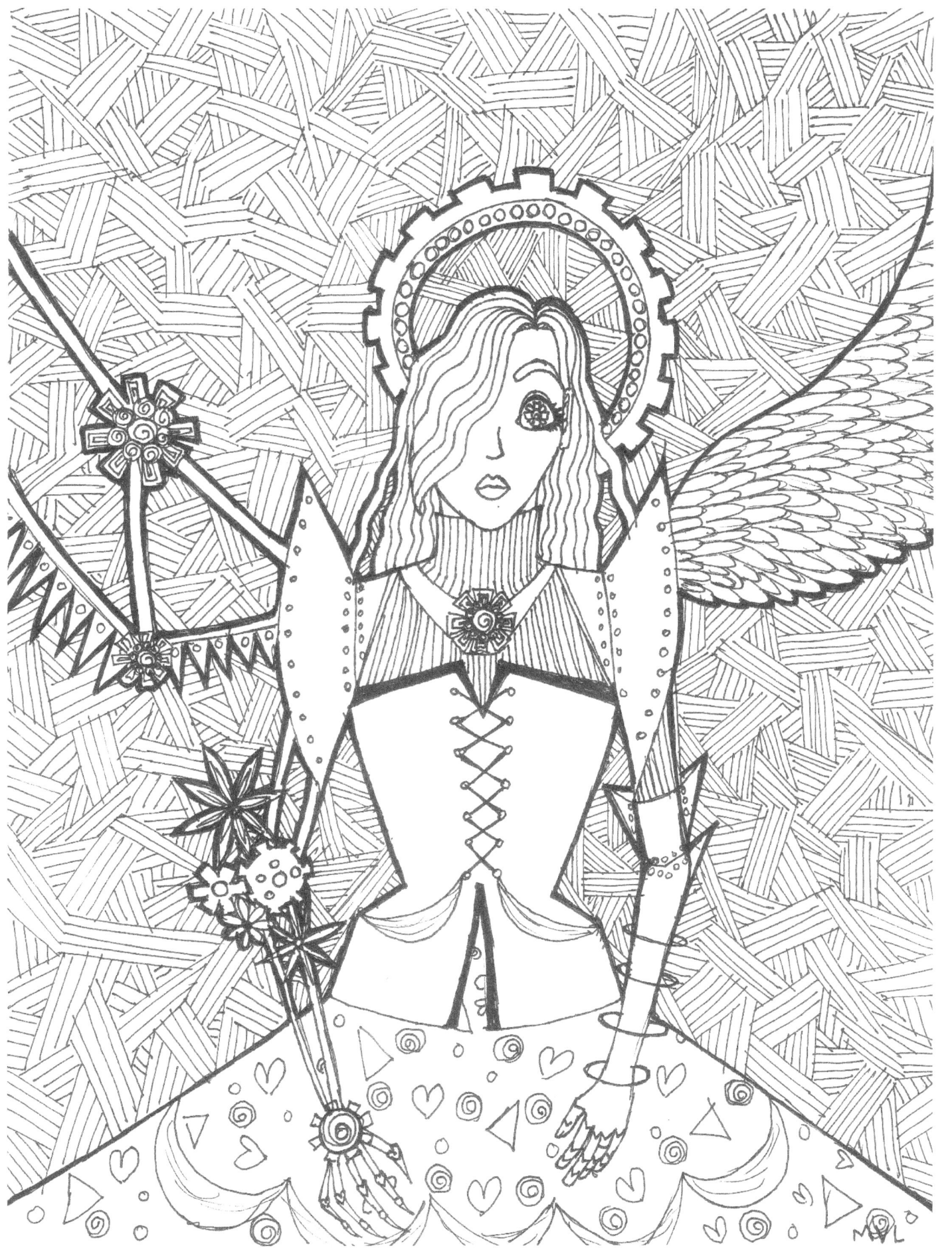

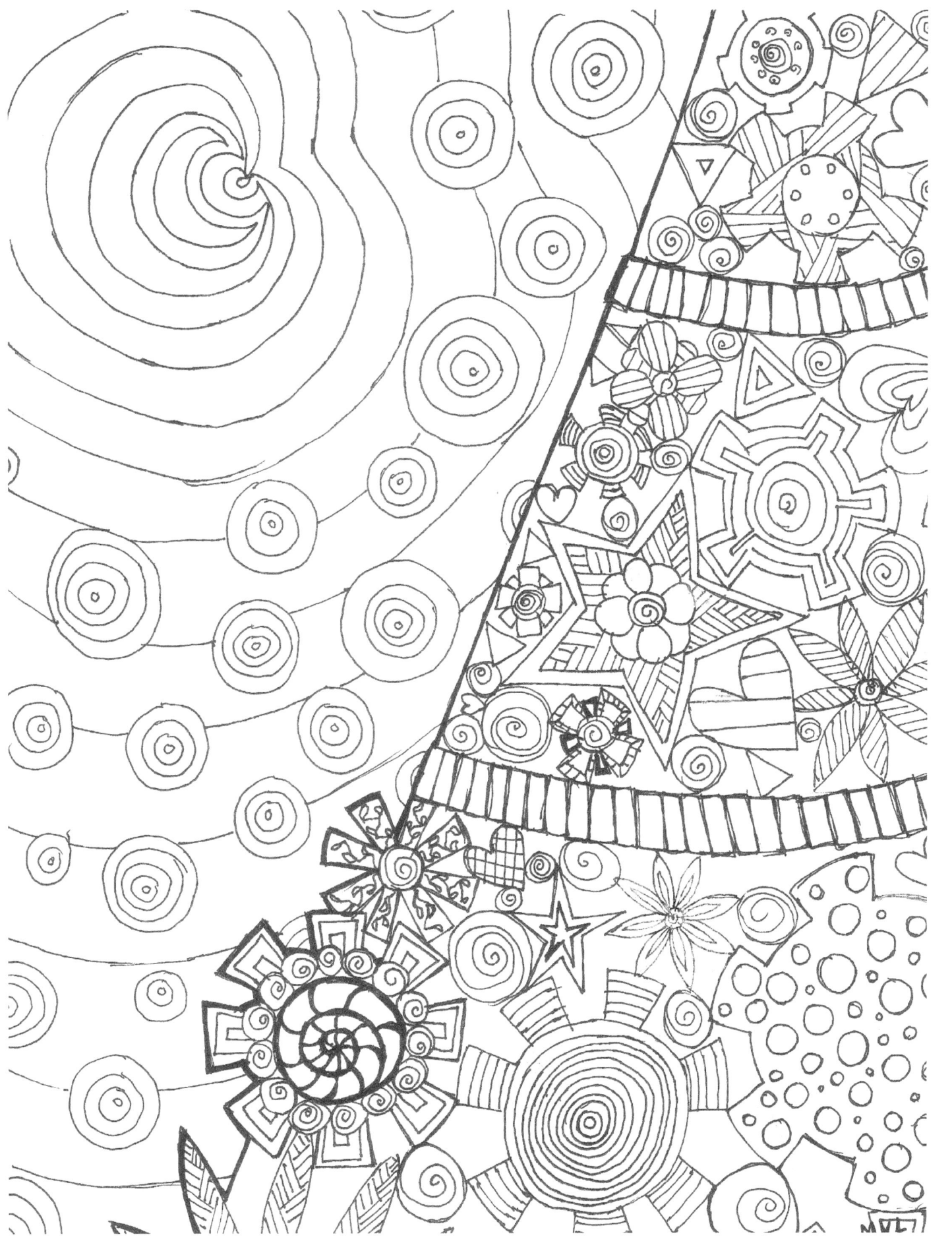

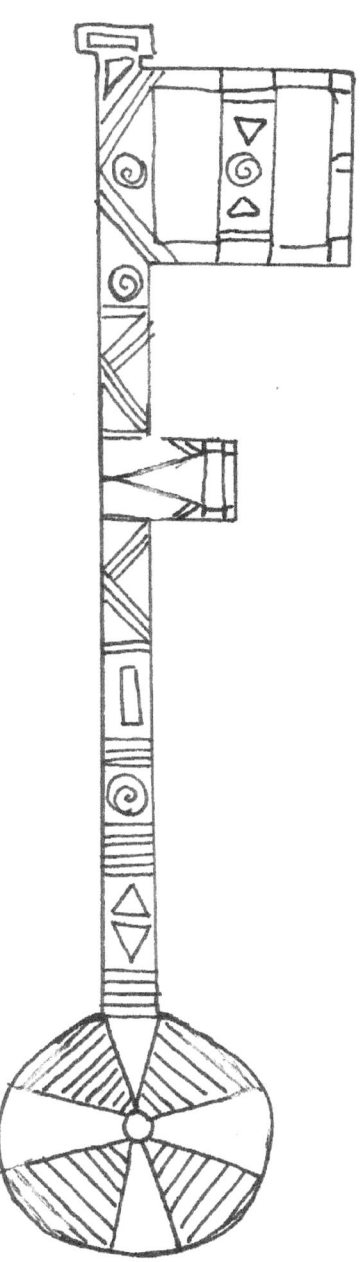

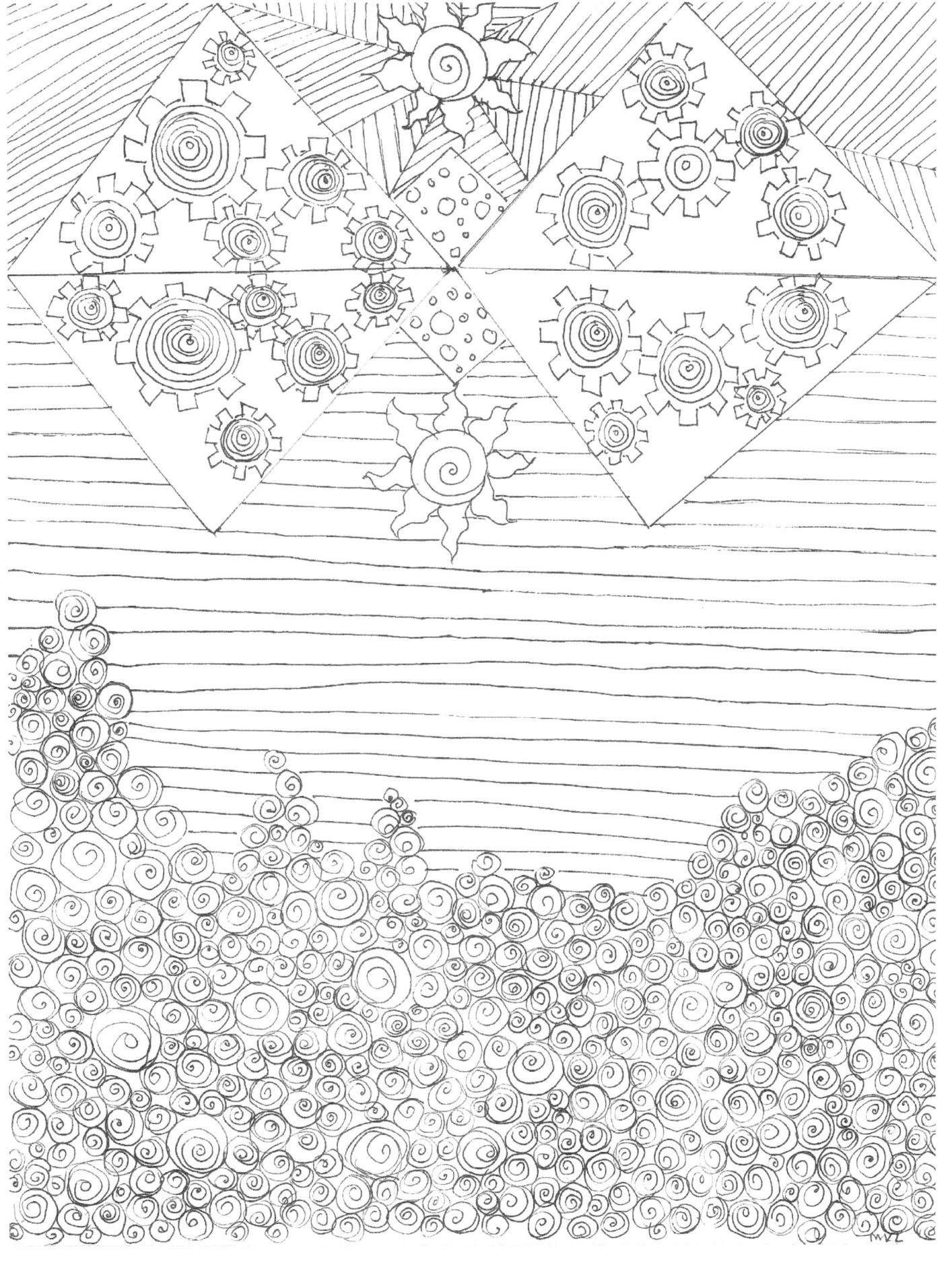

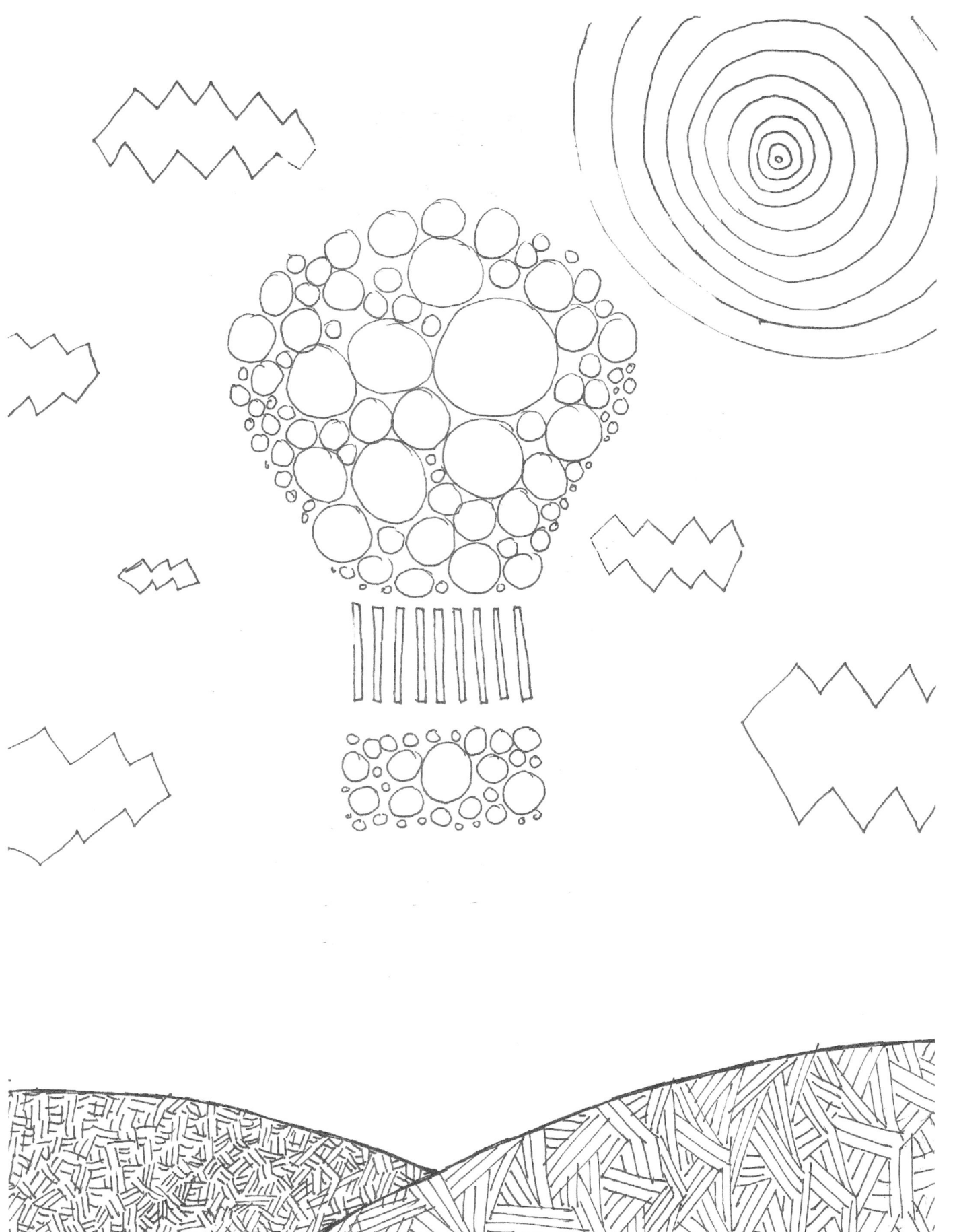

*Dedicated to Patricia Lovell, extraordinary artist and grandmother.*

Hello, everyone, thank you so much for purchasing this coloring book. I hope that coloring this was an enjoyable experience for you and that you got some pretty pictures out of it.

I would like to thank my husband, Richard Bruns, for his love and support as well as my parents, Michael and Kathleen Lovell. I would also like to thank Ashley Risteen, Courtney Isabelle, and Kala Gleason for their friendship. I would also like to thank the "S.O.D.V." girls for their feedback on this coloring book.

www.ingramcontent.com/pod-product-compliance
Lightning Source LLC
Chambersburg PA
CBHW080628190526
45169CB00009B/3322